W9-AZQ-953

THE WIT AND WISDOM OF

JAMES BOND

The Wit and Wisdom of James Bond
ISBN: 9781789098198

Published by
Titan Books
A division of Titan Publishing Group Ltd
144 Southwark St
London
SE1 0UP

www.titanbooks.com

First edition: October 2021
2 4 6 8 10 9 7 5 3 1

2021 © EON Productions Limited and Danjaq, LLC
007 and related James Bond Indica © 1962-2021 Danjaq, LLC and
Metro-Goldwyn-Mayer Studios Inc. *007* and related James Bond Trademarks are
trademarks of Danjaq, LLC. All Rights Reserved.

Did you enjoy this book? We love to hear from our readers. Please e-mail
us at: readerfeedback@titanemail.com or write to Reader Feedback at
the above address.

To receive advance information, news, competitions, and exclusive offers online, please sign
up for the Titan newsletter on our website: www.titanbooks.com

No part of this publication may be reproduced, stored in a retrieval system, or transmitted,
in any form or by any means without the prior written permission of the publisher, nor be
otherwise circulated in any form of binding or cover other than that in which it is published
and without a similar condition being imposed on the subsequent purchaser.

A CIP catalogue record for this title is available from the British Library.

Printed and bound in Italy.

THE WIT
AND WISDOM
OF

JAMES
BOND

007

JAMES NOLAN
SIMON WARD

TITAN
BOOKS

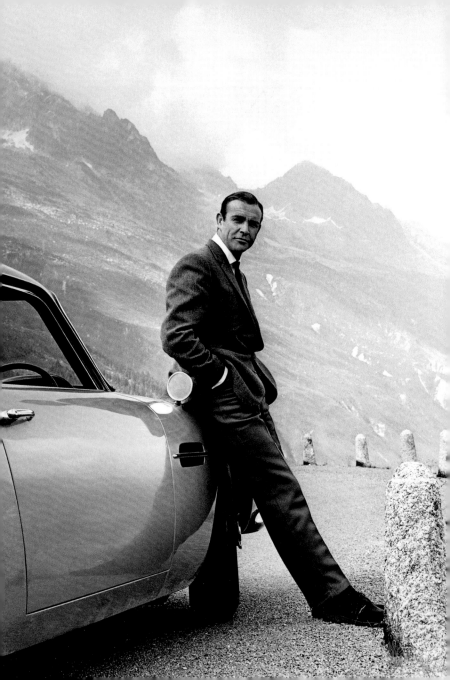

CONTENTS

Chapter 1

INTRODUCTIONS

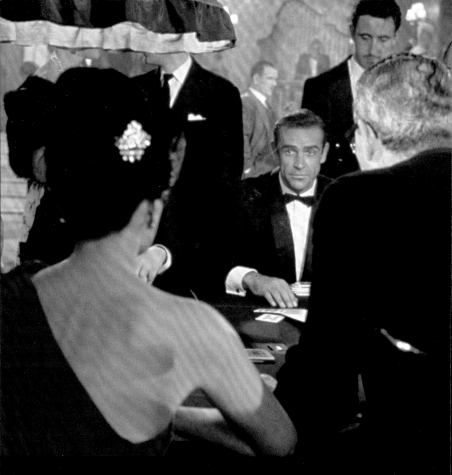

James Bond: I admire your courage. Miss, er?
Sylvia Trench: Trench. Sylvia Trench.
I admire your luck. Mr?
Bond: Bond. James Bond.

Dr. No

Bond: Tell me, Miss Trench, do you play any other games?
I mean besides Chemin de fer.

Dr. No

Vesper Lynd: I'm the money.
Bond: Every penny of it.

Casino Royale

Bond: You know, we've never formally been introduced.
Moneypenny: Oh. Well, my name's Eve. Eve Moneypenny.
Bond: Well, I look forward to our time together, Miss Moneypenny.
Moneypenny: Me, too. I'm sure we'll have one or two close shaves.

Skyfall

Octopussy: Good evening. I wondered when you might arrive.
Bond: So you are the mysterious Octopussy.
Octopussy: And you are James Bond, 007, licence to kill.
Am I to be your target for tonight?

Octopussy

Dr Christmas Jones: Doctor. Jones. Christmas
Jones. And don't make any jokes. I've heard 'em all.
Bond: I don't know any doctor jokes.

The World Is Not Enough

Honey Rider: What are you doing here? Looking for shells?
Bond: No. I'm just looking.
Honey Rider: Stay where you are.
Bond: I promise I won't steal your shells.
Honey Rider: I promise you, you won't either. Stay where you are!

Dr. No

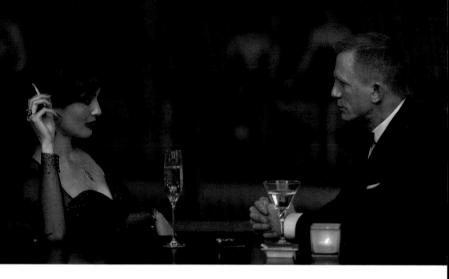

Severine: It has to do with death.
Bond: A subject in which you're well versed.
Severine: And how would you know that?
Bond: Only a certain kind of woman wears a backless dress with a Beretta .70 strapped to her thigh.
Severine: One can never be too careful when handsome men in tuxedos carry Walthers.

Skyfall

Kamran Shah: Thank you both for your help. My name is Kamran Shah. Please forgive the theatricals, it's a hangover from my Oxford days.

The Living Daylights

Mr Big: Names is for tombstones, baby.
Live And Let Die

Mr Kil: I'm Mr. Kil.
Bond: Well, there's a name to die for.
Die Another Day

Tiger Tanaka: Permit me to introduce myself.
My name is Tanaka. Please call me Tiger.
Bond: If you're Tanaka, how do you feel about me?
Tiger Tanaka: I... love you.
Bond: Well, I'm glad we got that out of the way.
You Only Live Twice

Bond: My sources tell me you're Bolivian Secret Service. Or used to be.
And that you infiltrated Greene's organization by having sex with him.
Camille: That offends you?
Bond: No. Not in the slightest.
Quantum Of Solace

Hugo Drax: You have arrived at a propitious moment, coincident
with your country's one indisputable contribution to Western
civilization: Afternoon tea. May I press you to a cucumber sandwich?
Moonraker

Vesper Lynd: Now, having just met you,
I wouldn't go as far as calling you a cold-hearted bastard...
Bond: No, of course not.
Vesper Lynd: But it wouldn't be a stretch to imagine
you think of women as disposable pleasures rather than
meaningful pursuits. So as charming as you are,
Mr Bond, I will be keeping my eye on our government's
money and off your perfectly formed arse.
Bond: You noticed?
Vesper Lynd: Even accountants have imagination.

Casino Royale

Bond: Hello. I thought you might like to join the party.
By the way, the name is James St John Smythe. I'm English.
Stacey Sutton: Hm. I never would have guessed.
A View To A Kill

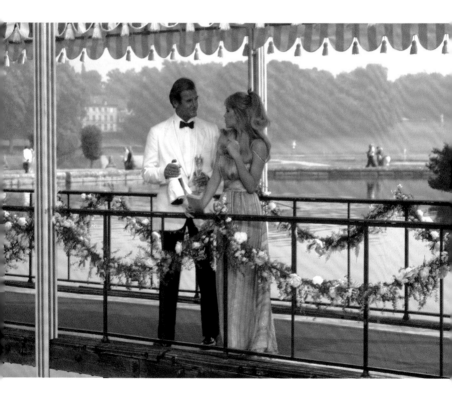

Felix Leiter: Sorry, I should have introduced myself, seeing as we're related. Felix Leiter, a brother from Langley.

Casino Royale

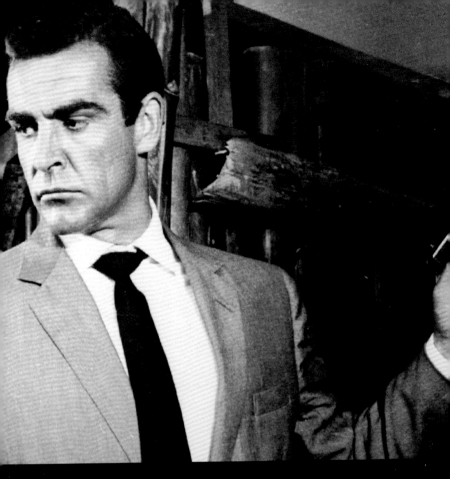

Felix Leiter: Interesting.
Where were you measured for this, bud?
Bond: My tailor. Savile Row.
Felix Leiter: That so? Mine's a guy in Washington.
Felix Leiter. Central Intelligence Agency.

Dr. No

Q: 007... I'm your new Quartermaster.
Bond: You must be joking.
Q: Why, because I'm not wearing a lab coat?
Bond: Because you still have spots.
Q: My complexion is hardly relevant.
Bond: Well, your competence is.
Q: Age is no guarantee of efficiency.
Bond: And youth is no guarantee of innovation.

Skyfall

Draco: Do not kill me, Mr Bond. At least not until we've had a drink. Then, if you wish, I'll give you another chance.

On Her Majesty's Secret Service

Ernst Stavro Blofeld: James Bond, allow me to introduce myself. I am Ernst Stavro Blofeld. They told me you were assassinated in Hong Kong.

Bond: Yes, this is my second life.

Ernst Stavro Blofeld: You only live twice, Mr Bond.

You Only Live Twice

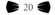

Chapter 2

JAMES BOND

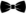

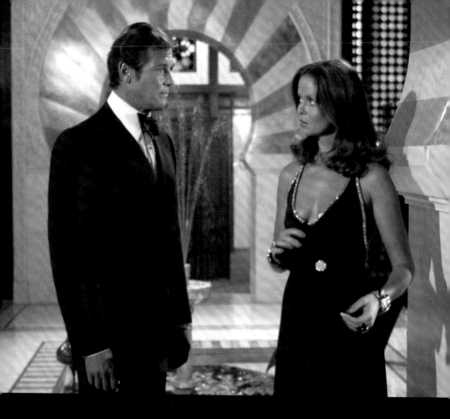

Major Anya Amasova: Commander James Bond, recruited to the British Secret Service from the Royal Navy. Licenced to kill and has done so on numerous occasions. Many lady friends, but married only once. Wife killed...
Bond: Alright, you've made your point.
Major Anya Amasova: You're sensitive, Mr Bond?
Bond: About certain things, yes.

The Spy Who Loved Me

Alec Trevelyan: Oh please, James, spare me the Freud. I might as well ask you if all the vodka martinis ever silence the screams of all the men you've killed. Or if you find forgiveness in the arms of all those willing women – for all the dead ones you failed to protect.

GoldenEye

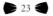

Gonzales: A Walther PPK. Standard issue.
British Secret Service. Licence to kill – or be killed. Take him away.

For Your Eyes Only

Bond: That gun, looks more fitting for a woman.
Largo: You know much about guns, Mr Bond?
Bond: No. I know a little about women.

Thunderball

Madeleine Swann: Why would I betray you?
Bond: We all have our secrets. We just didn't get to yours yet.

No Time To Die

Bond: Stuff my orders! I only kill professionals. That girl didn't know
one end of a rifle from the other. Go ahead. Tell him what you want.
If he fires me, I'll thank him for it. Whoever she was, it must
have scared the living daylights out of her.

The Living Daylights

Bond: I'm truly sorry to have to dash off like this,
but there's been a bit of a flap at the office.
Patricia Fearing: What kind of work do you do, anyway?
Bond: Oh, I travel. A sort of... licenced trouble-shooter.

Thunderball

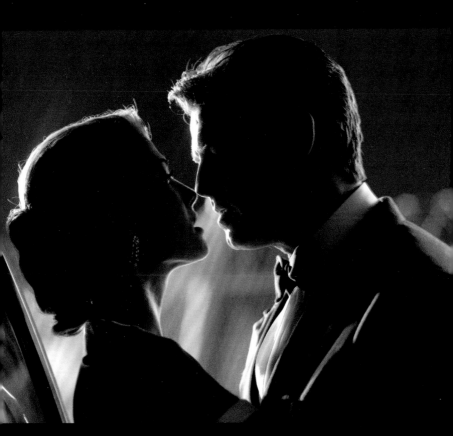

Miranda Frost: Remember I know all about you, 007. Sex for dinner, death for breakfast. Well, it's not going to work with me.

Die Another Day

Dr Hall: I'd like to start with some simple word associations. Just tell me the first word that pops into your head. For example, I might say, "Day," and you might say...

Bond: Wasted.

Dr Hall: Alright... Gun.

Bond: Shot.

Dr Hall: Agent.

Bond: Provocateur.

Dr Hall: Woman.

Bond: Provocatrix.

Dr Hall: Heart.

Bond: Target.

Dr Hall: Bird.

Bond: Sky.

Dr Hall: M.

Bond: Bitch.

Dr Hall: Sunlight.

Bond: Swim.

Dr Hall: Moonlight.

Bond: Dance.

Dr Hall: Murder.

Bond: Employment.

Dr Hall: Country.

Bond: England.

Dr Hall: Skyfall.

Bond: ...

Dr Hall: Skyfall.

Bond: Done.

Skyfall

Elektra King: I could have given you the world.
Bond: The world is not enough.
Elektra King: Foolish sentiment.
Bond: Family motto.
The World Is Not Enough

Felicca: You are very suspicious, Mr Bond.
Bond: Oh, I find I live much longer that way.
The Spy Who Loved Me

Bond: Governments change.
The lies stay the same.
GoldenEye

Bond: Why is it people who can't take
advice always insist on giving it?
Casino Royale

Wai Lin: Exactly what kind of banking
do you specialise in, Mr Bond?
Bond: Hostile takeovers.
Tomorrow Never Dies

Bond: I read your obituary of me.
M: And?
Bond: Appalling.
M: Yeah, I knew you'd hate it. I did call you
"an exemplar of British fortitude".
Bond: That bit was all right.
Skyfall

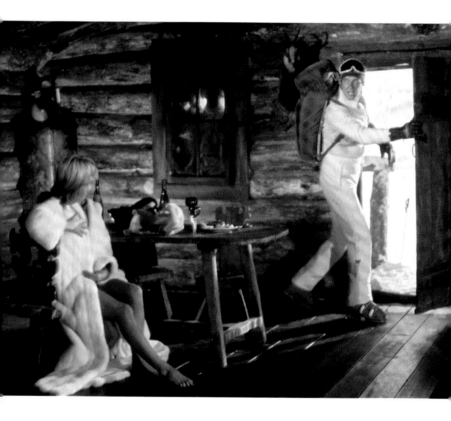

Log Cabin Agent: But James, I need you!
Bond: So does England!

The Spy Who Loved Me

Bond: In my business you prepare for the unexpected.
Franz Sanchez: And what business is that?
Bond: I help people with problems.
Franz Sanchez: Problem solver.
Bond: More of a problem eliminator.

Licence To Kill

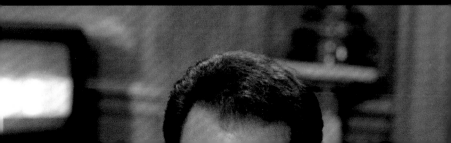

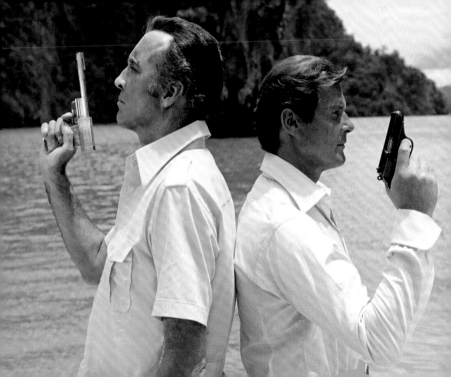

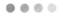

Bond: As you can see, I have no problem with female authority.

GoldenEye

Vesper Lynd: It doesn't bother you, killing those people?
Bond: Well, I wouldn't be very good at my job if it did.

Casino Royale

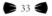

Madeleine Swann: I see you left this final question blank. What is your occupation?
Bond: Well, that's not the sort of thing that looks good on a form.
Madeleine Swann: And why is that?
Bond: I kill people.

Spectre

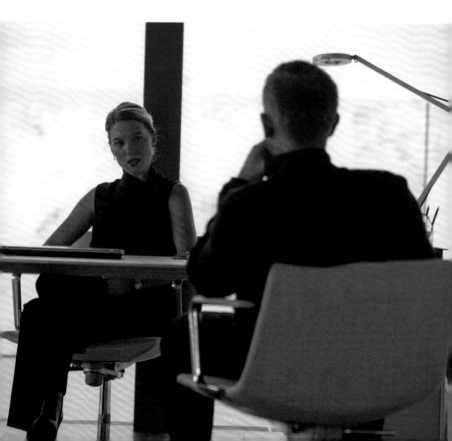

Major Boothroyd: It's nice and light...
in a lady's handbag. No stopping power.
M: Any comment, 007?
Bond: I disagree, sir. I've used the Beretta for ten years.
I've never missed with it yet.
M: Maybe not, but it jammed on your last job, and you
spent six months in hospital in consequence. If you carry a
double-o number, it means you're licenced to kill, not get
killed. And another thing, since I've been head of MI7 there's
been a forty per cent drop in double-o operative casualties.
I want it to stay that way. You'll carry the Walther.

Franz Oberhauser: Welcome, James.
It's been a long time. But, finally, here we are.
What took you so long?

Spectre

OFFICE POLITICS

Moneypenny: Flattery'll get you nowhere – but don't stop trying.

Dr. No

M: If there's even the slightest chance, Bond will succeed. He's the best we have. Though I'd never tell him.

The World Is Not Enough

M: Miss Moneypenny, give 007 the password
we've agreed with Japanese S.I.S.
Moneypenny: Yes, sir. We tried to think of
something that you wouldn't forget.
Bond: Yes?
Moneypenny: I. Love. You. Repeat it, please, to make sure you get it.
Bond: Don't worry, I get it. *Sayonara.*
Moneypenny: James, good luck. *Instant Japanese.* You may need it.
Bond: You forget, I took a first in Oriental Languages at Cambridge.

You Only Live Twice

Q: Now, a new watch. This will be your twentieth, I believe.
Bond: How time flies.

Die Another Day

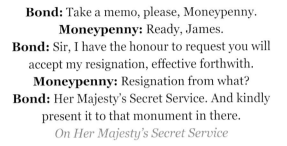

Bond: Take a memo, please, Moneypenny.
Moneypenny: Ready, James.
Bond: Sir, I have the honour to request you will accept my resignation, effective forthwith.
Moneypenny: Resignation from what?
Bond: Her Majesty's Secret Service. And kindly present it to that monument in there.
On Her Majesty's Secret Service

Bond: Good evening, sir.
M: It happens to be 3 a.m. When do you sleep, 007?
Bond: Never on the firm's time, sir.
Dr. No

Bond: Sir, I respectfully suggest that you change my assignment to Nassau.
M: Is there any other reason, besides your enthusiasm for water sports?
Thunderball

Bond: I mean, sir, who would pay a million dollars to have me killed?
M: Jealous husbands, outraged chefs, humiliated tailors. The list is endless.
The Man With The Golden Gun

Bond: Ejector seat? You're joking.
Q: I never joke about my work, 007.

Goldfinger

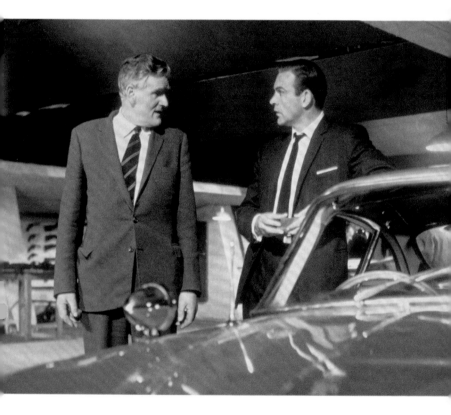

M: Because I think you're a sexist, misogynist dinosaur, a relic of the Cold War.

GoldenEye

M: Who the hell do they think they are? I report to the Prime Minister and even he's smart enough not to ask me what we do. Have you ever seen such a bunch of self-righteous, arse-covering prigs? They don't care what we do, they care what we get photographed doing. And how the hell could Bond be so stupid? I give him double-o status and he celebrates by shooting up an embassy. Is the man deranged? And where the hell is he? In the old days if an agent did something that embarrassing, he'd have the good sense to defect. Christ, I miss the Cold War.

Casino Royale

Bond: I thought "M" was a randomly assigned letter.
I had no idea it stood for—
M: Utter one more syllable and I'll have you killed.

Casino Royale

Moneypenny: I've been reassigned.
Temporary suspension from field work.
Bond: Really?
Moneypenny: Mmm. Something to do with killing 007.
Bond: Well, you gave it your best shot.
Moneypenny: It was hardly my best shot.
Bond: Not sure I could survive your best.
Moneypenny: I doubt you'll get the chance.

Skyfall

Q: Try to be a little less than your usual frivolous self, 007.
Thunderball

M: You don't trust anyone, do you, James?
Bond: No.
M: Then you've learnt your lesson.
Casino Royale

Bond: A gun and a radio. Not exactly Christmas, is it?
Q: Were you expecting an exploding pen?
We don't really go in for that anymore.
Skyfall

M: I assume you have no regrets.
Bond: I don't. What about you?
M: Of course not. It would be unprofessional.
Quantum Of Solace

Camille: So, what's your interest in Greene?
Bond: Amongst other things, he tried to kill a friend of mine.
Camille: A woman?
Bond: Yes. But it's not what you think.
Camille: Your mother?
Bond: She likes to think so.
Quantum Of Solace

M: And Bond, if you could avoid killing every possible lead, it would be deeply appreciated.

Quantum Of Solace

Bond: Q, have I ever let you down?
Q: Frequently.

The Spy Who Loved Me

M: Ask him about Slate.
Bill Tanner: She wants to know about Slate.
Bond [on phone]: Tell her Slate was a dead end.
Bill Tanner: Slate was a dead end.
M: Damn it! He killed him.

Quantum Of Solace

Nomi: The world's moved on, Commander Bond.
Bond: You a double-0?
Nomi: Two years. So stay in your lane. You get in my way,
I will put a bullet in your knee... The one that works.

No Time To Die

Q: Need I remind you, 007, that you have a licence to kill,
not to break the traffic laws.

GoldenEye

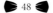

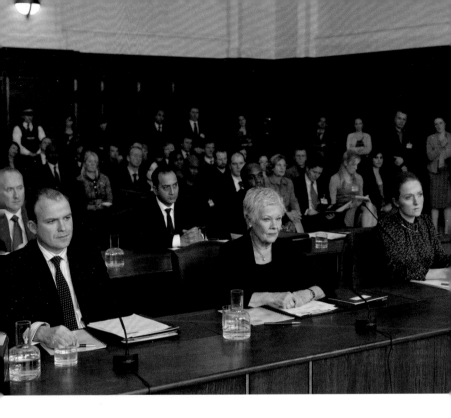

M: Look around you. Who do you fear? Can you see a face? A uniform? A flag? No. Our world is not more transparent now. It's more opaque. It's in the shadows. That's where we must do battle. So, before you declare us irrelevant, ask yourselves: How safe do you feel?

Skyfall

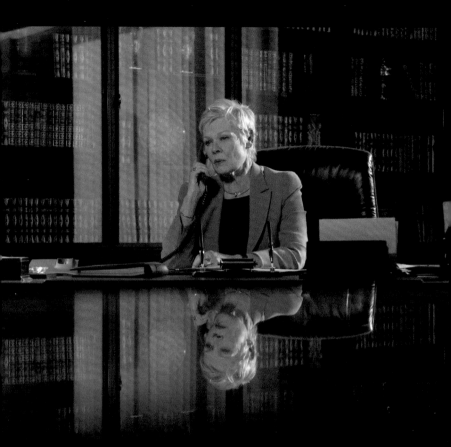

M: Sometimes we're so focussed on our enemies we forget to watch our friends.

Casino Royale

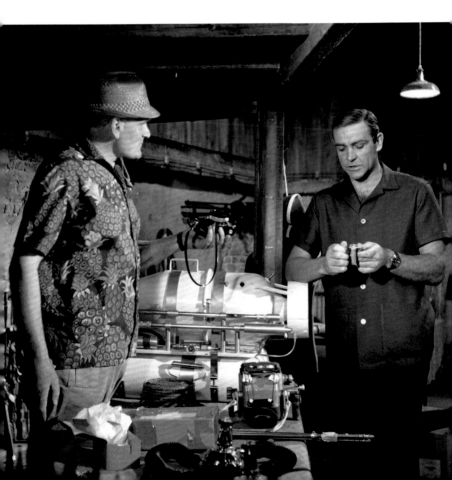

Q: Now here's something I want you to use with special care. With special care.

Bond: Everything you give me...

Q: Is treated with equal contempt. Yes, I know.

Thunderball

Nomi: I get why you shot him.
Moneypenny: Yeah, well, everyone tries at least once.
No Time To Die

Bond: Was there ever a man more misunderstood?
Moneypenny: Now James, you can't pull the wool over
my eyes. You may be able to con the old man,
but I know better. I could—
M: So do I, Miss Moneypenny. And I'll thank you not
to refer to me as "the old man".
Thunderball

Q: I've been saying for years, sir, our special equipment is obsolete. And now, computer analysis reveals an entirely new approach: miniaturization. For instance, radioactive lint. When placed in an opponent's pockets, the antipersonnel and location fix seems fairly obvious.
M: What we want is a location fix on 007.
On Her Majesty's Secret Service

Q: I'll hazard I can do more damage on my laptop sitting in my pyjamas before my first cup of Earl Grey than you can do in a year in the field.
Skyfall

M: You killed a man in Bregenz.
Bond: I did my best not to.
M: You shot him at point blank and threw him off a roof. I'd hardly call that showing restraint!
Quantum Of Solace

Q: So you're not dead.
Bond: Hello, Q. I've missed you.
No Time To Die

Bond: Little Nellie got a hot reception. Four big shots made improper advances towards her, but she defended her honour with great success.
You Only Live Twice

Q: Oh, don't be an idiot, 007. I know exactly what you're up to, and quite frankly, you're going to need my help. Remember, if it hadn't been for Q Branch, you'd have been dead long ago.

Licence To Kill

Chapter 4

FOREIGN RELATIONS

Bond: You know, I was just wondering what South America would look like if nobody gave a damn about coke or communism. It's always impressed me the way you boys have carved this place up.
Felix Leiter: I'll take that as a compliment coming from a Brit.

Quantum Of Solace

M: I would have expected the KGB to celebrate if Silicon Valley had been destroyed.
General Gogol: On the contrary, admiral, where would Russian research be without it?

A View To A Kill

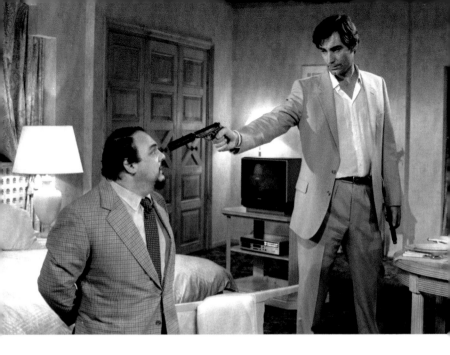

General Leonid Pushkin: You are professional.
You do not kill without reason.
Bond: Two of our men are dead. Koskov's named you.
Now, why should I disobey my orders?
General Leonid Pushkin: I am in the dark as much as
you are. It is a question of trust.
Who do you believe? Koskov or me?
Bond: If I trusted Koskov we wouldn't be talking. But as
long as you're alive, we'll never know what he's up to.
General Leonid Pushkin: Then I must die.
The Living Daylights

Bond: Oh, you see, that's what I like about US intelligence.
You'll lie down with anybody.
Felix Leiter: Including you, brother. Including you.
Quantum Of Solace

Bond: When someone's behind
you on skis at forty miles an hour trying to
put a bullet in your back, you
don't always have time to remember a face.
The Spy Who Loved Me

Bond: Oh, I suppose you're right, Holly. We would be
better off working together. Détente?
Holly Goodhead: Agreed.
Bond: Understanding?
Holly Goodhead: Possibly.
Bond: Cooperation?
Holly Goodhead: Maybe.
Bond: Trust?
Holly Goodhead: Out of the question.
Moonraker

Bond: Just relax. I have a friend named
Felix who can fix anything.
Diamonds Are Forever

General Gogol: You will come back to us, comrade.
No one ever leaves the KGB.
A View To A Kill

Bond: If you can't trust a Swiss banker,
what's the world come to?
The World Is Not Enough

Tiffany Case: You did talk to your friend Felix about me?
Well, what did he say?
Bond: Something about twenty years to life. Nothing important.
Diamonds Are Forever

US Police Captain: You're under arrest.
Stacey Sutton: Wait a minute, this is James Stock
of the London *Financial Times*.
Bond: Well, actually, captain, I'm with the
British Secret Service.
The name is Bond, James Bond.
US Police Captain: Is he?
Stacey Sutton: Are you?
Bond: Yes.
US Police Captain: And I'm Dick Tracy and
you're still under arrest!
A View To A Kill

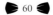

M: I couldn't give a shit about the CIA or their trumped-up evidence. He's my agent – and I trust him.

Quantum Of Solace

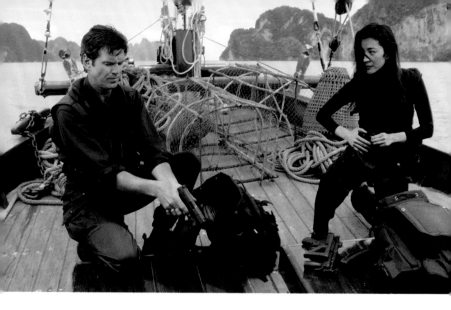

Wai Lin: It's mostly dull routine, of course, but every now and then you get to sail on a beautiful evening like this and sometimes work with a decadent agent of a corrupt Western power.
Bond: And they say communists don't know how to have fun.

Tomorrow Never Dies

Kronsteen: My reading of the British mentality is that they always treat a trap as a challenge.

From Russia With Love

Kara Milovy: You dumb, stubborn, stupid
zadnyaya chast' loshadi!
Bond: What's that supposed to mean?
Kara Milovy: Back end of horse!
Bond: Are you calling me a horse's arse?
The Living Daylights

Felix Leiter: Well, hello double-o—
Bond: Shhh.
Felix Leiter: That's a fine way to treat the CIA.
Bond: Sorry about that, Felix, but you were
about to say "double-o seven".
Felix Leiter: Well, James, have you killed him?
Bond: You know me better than that.
Thunderball

Pola Ivanova: Détente can be beautiful.
Bond: This is no time to be discussing politics.
A View To A Kill

Rosie Carver: Felix told me there'd
be moments like this.
Bond: What did good old Felix suggest?
Rosie Carver: If all else failed, cyanide pills.
Live And Let Die

General Georgi Koskov: Power has gone to his head.
He's sick, like Stalin. He hates our new policy of détente.
I have here a secret directive from Pushkin: *Smiert Spionam.*
Bond: "Death to Spies," minister.
General Georgi Koskov: *Da*! For an assassination program,
with list of targets – British and American agents.
When this starts, you will retaliate. Murder will follow murder.
Soviet and Western Intelligence could destroy each other.
God forbid, this might lead to nuclear war!
Unless Pushkin can be – How do you say? – "put away".
The Living Daylights

Tiger Tanaka: How is that for Japanese efficiency?
Bond: Just a drop in the ocean.
You Only Live Twice

Hugo Drax: You must excuse me, gentlemen. Not being English,
I sometimes find your sense of humour rather difficult to follow!
Moonraker

General Georgi Koskov: [Laughing] As Russians say,
"Heart and stomachs, good comrades made." What's this?
Caviar. Well, that's peasant food for us,
but with champagne it's okay. Bollinger R.D. – the best!
The Living Daylights

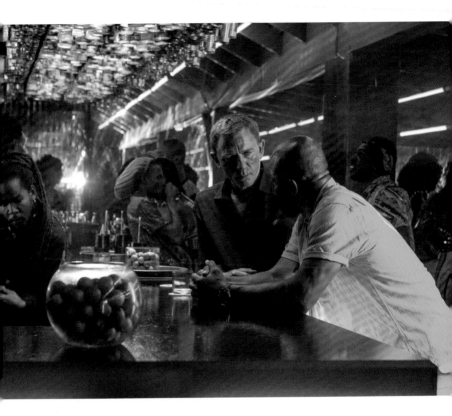

Felix Leiter: Harder to tell the good from bad, villains from heroes these days.

No Time To Die

Ernst Stavro Blofeld: You perverse British.
How you love your exercise.

On Her Majesty's Secret Service

A QUESTION
OF TASTE

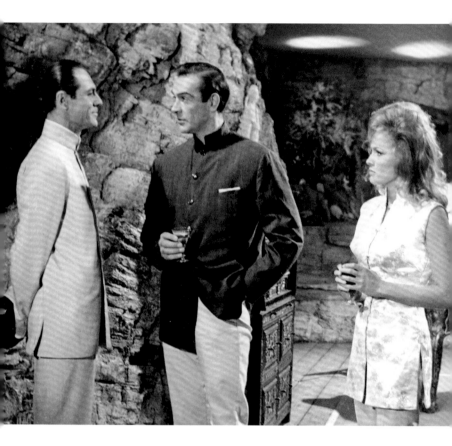

Dr No: A medium dry martini,
lemon peel, shaken, not stirred.

Dr. No

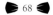

Bond: Although for such a grand meal
I had rather expected a claret.
Mr Wint: Of course. Unfortunately, our cellar is
rather poorly stocked with clarets.
Bond: Mouton Rothschild is a claret. And I've smelt that
aftershave before and both times I've smelt a rat.

Diamonds Are Forever

Henderson: That's stirred, not shaken. That was right, wasn't it?
Bond: Perfect. Cheers.
Henderson: Cheers.
Bond: Russian vodka. Well done.
Henderson: Yeah, I get it from the doorman at
the Russian embassy... among certain other things.

You Only Live Twice

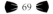

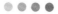

Bond: Dry martini.
Bartender: *Oui, monsieur.*
Bond: Wait. Three measures of Gordon's, one of vodka, half a measure of Kina Lillet, shake it over ice, and then add a thin slice of lemon peel.
Casino Royale

Bond: Vodka martini.
Bartender: Shaken or stirred?
Bond: Do I look like I give a damn?
Casino Royale

Bond: Never mind that. Go and get the brandy, huh?
Five-star Hennessy, of course.
On Her Majesty's Secret Service

Bond: Red wine with fish. Now that should have told me something.
From Russia With Love

Bond: Bollinger? If it's '69 you were expecting me.
Moonraker

Moneypenny: I didn't know you were such a music lover, James.
Anytime you want to drop by and listen to my Barry Manilow collection...
The Living Daylights

Bond: Oh, room service, this is Mr Bond, bungalow 12.
I'd like a bottle of Bollinger, please. Slightly chilled.
Two glasses. Thank you.

Live And Let Die

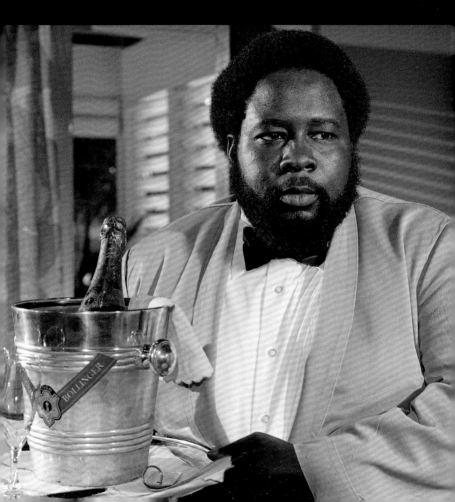

Tiger Tanaka: Do you like Japanese sake, Mr Bond?
Or would you prefer vodka martini?
Bond: Oh no, I like sake. Especially when it's served at the
correct temperature. 98.4 degrees Fahrenheit, like this is.
Tiger Tanaka: For a European, you are exceptionally cultivated.
You Only Live Twice

Colonel Smithers: Have a little more of this
rather disappointing brandy.
M: Well, what's the matter with it?
Bond: I'd say it was a thirty-year-old *fine*, indifferently
blended, sir. With an overdose of Bon Bois.
Goldfinger

Chapter 6
<u> </u>

CRIMINAL MINDS

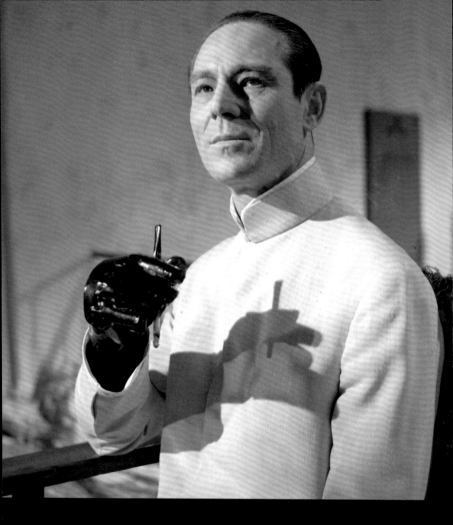

Dr No: The successful criminal brain is always superior.
It has to be.

Franz Sanchez: Everyone and his brother is on the payroll. So, you buy a mayor, chief of police, generals, presidents. One day you wake up and you own the whole god damn country. Then you take what you want. Bank. Gambling casino. Airline concession. Why? Simple. It's easier for the politicians to take silver, than lead.
Licence To Kill

Bond: World domination, that same old dream. Our asylums are full of people who think they are Napoleon. Or God.
Dr. No

Hugo Drax: At least I shall have the pleasure of putting you out of my misery.
Moonraker

Holly Goodhead: Hang on, James.
Bond: The thought had occurred to me.
I might have guessed.
Holly Goodhead: Do you know him?
Bond: Not socially. His name's Jaws. He kills people.
Moonraker

Franz Oberhauser: He's a visionary, like me.
Bond: Visionaries... Psychiatric wards are full of them.
Spectre

Ernst Stavro Blofeld: James, fate draws us back together. Now your enemy is my enemy.

No Time To Die

Kamal Khan: Mr Bond is indeed a very rare breed. Soon to be made extinct.

Octopussy

Scaramanga: I like a girl in a bikini. No concealed weapons.

The Man With The Golden Gun

Hugo Drax: Look after Mr Bond. See that some harm comes to him.

Moonraker

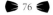

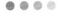

Scaramanga: You see, Mr Bond, like every great artist I want to create an indisputable masterpiece once in my lifetime. The death of 007 – mano a mano, face to face – will be mine.

The Man With The Golden Gun

Goldfinger: Choose your next witticism carefully, Mr Bond. It may be your last.

Goldfinger

Hugo Drax: Allow me to introduce you to the airlock chamber. Observe, Mr Bond, your route from this world to the next. And you, Dr Goodhead, your desire to be America's first woman in space will shortly be fulfilled.

Moonraker

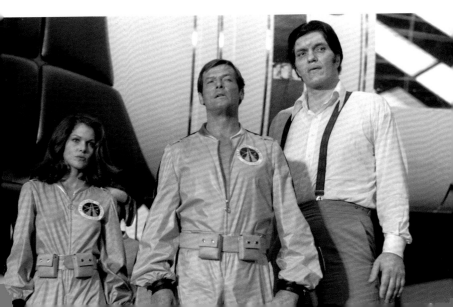

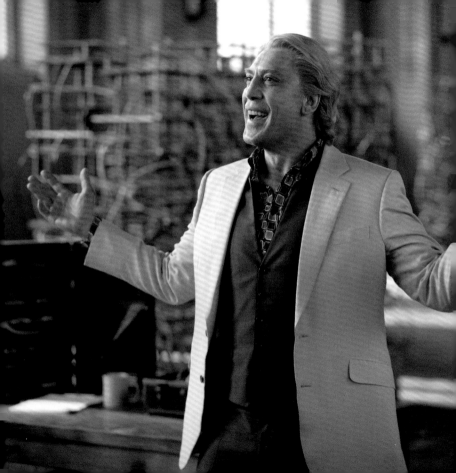

Raoul Silva: So how do you get rats off an island? Hmm? My grandmother showed me. We buried an oil drum and hinged the lid, then we wired coconut to the lid as bait. And the rats would come for the coconut and – *boing boing boing boing boing boing* – they would fall into the drum. Then after a month you have trapped all the rats. But what do you do then? Throw the drum into the ocean? Burn it? No. You just leave it. And they begin to get hungry. And one by one they start eating each other until there are only two left. The two survivors. And then what? Do you kill them? No. You take them and release them into the trees. But now they don't eat coconut anymore. Now they only eat rat. You have changed their nature. The two survivors. This is what she made us.

Skyfall

Dr No: I gave orders that he should be killed.
Why is he still alive?
Professor Dent: Our attempts failed.
Dr No: Your attempts failed. I do not like failure.
You are not going to fail me again, professor.

Dr. No

Renard: Yes. And now we also share a common fate. You will die. Along with everyone in this city. And the bright, starry, oil-driven future of the West. Since you sent your man to kill me, I've been watching time tick slowly away, marching toward my own death. Now you can have the same pleasure. Watch these hands, M. By noon tomorrow, your time is up. And I guarantee you, I will not miss.

The World Is Not Enough

Alec Trevelyan: What's true is that in 48 hours you and I will have more money than God, and Mr Bond here will have a small memorial service with only Moneypenny and a few tearful restaurateurs in attendance.

GoldenEye

Safin: James Bond. We both eradicate people to make the world a better place. I just want to be a little... tidier.

No Time To Die

Bond: The price for NOT firing those nuclear missiles?
Stromberg: You're deluded, Mr Bond. I'm not interested in extortion. I intend to change the face of history.
Major Anya Amasova: By destroying the world?
Stromberg: By creating a world, a new and beautiful world beneath the sea. Today's civilization, as we know it, is corrupt and decadent. Inevitably, it will destroy itself. I'm merely accelerating the process.
Major Anya Amasova: That does not justify mass murder.
Stromberg: For that, major, I will accept the judgement of posterity.

The Spy Who Loved Me

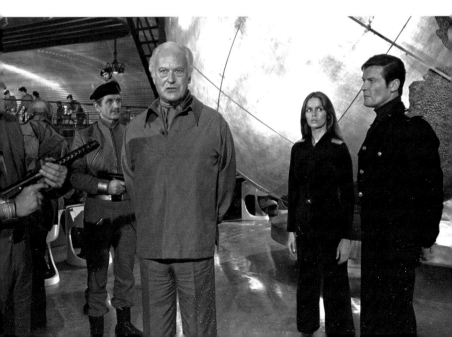

Bond: You really are quite insane.
Elliot Carver: The distance between insanity
and genius is measured only by success.

Tomorrow Never Dies

Safin: James Bond. Licence to kill. History of violence.
I could be speaking to my own reflection. Only your skills die
with your body. Mine will survive long after I'm gone.
Bond: History isn't kind to men who play God.

No Time To Die

Scaramanga: You see, Mr Bond, I always thought I liked animals.
Then I discovered that I like killing people even more.

The Man With The Golden Gun

Max Zorin: Gentlemen, for centuries alchemists tried to make gold from base metals. Today, we make microchips from silicon, which is common sand; but far better than gold. Hmmm. Now, for several years, we've had a profitable partnership, you as manufacturers, while I acquired and passed on to you industrial information that made you competitive, successful. We are now in the unique position to form an international cartel to control not only production, but distribution of these microchips. There is one obstacle – Silicon Valley, near San Francisco. Over 250 plants, employing thousands of scientists, technicians. This is the heartland of electronic production in the United States, which accounts for, what, eighty per cent of the world microchip market. I propose to... *end* the domination of Silicon Valley and leave us in control of that market.

A View To A Kill

Goldfinger: This is gold, Mr Bond. All my life I've been in love with its colour, its brilliance, its divine heaviness. I welcome any enterprise that will increase my stock. Which is considerable.

Goldfinger

Hugo Drax: No doubt, you have realised the splendour of my conception. First: A necklace of death about the Earth. Fifty globes, each releasing its nerve gas over a designated area, each capable of killing one hundred million people. The human race, as you know it, will cease to exist. Then, a rebirth, a new world.

Moonraker

Chapter 7

SPECTRE

Ernst Stavro Blofeld #1: Good evening, Mr Bond.
Bond: Blofeld.
Ernst Stavro Blofeld #2: Good evening, 007.
Ernst Stavro Blofeld #1: Double jeopardy, Mr Bond.
Ernst Stavro Blofeld #2: You killed my only other double, I'm afraid. After his death, volunteers were, understandably... rather scarce.

Diamonds Are Forever

Mr White: You really don't know anything about us. It's so amusing because we are on the other side, thinking, "Oh, the MI6, the CIA, they're looking over our shoulders. They're listening to our conversations." And the truth is you don't even know we exist.

M: Well, we do now, Mr White, and we're quick learners.

Quantum Of Solace

Ernst Stavro Blofeld: Siamese fighting fish. Fascinating creatures. Brave, but on the whole stupid. Yes, they're stupid. Except for the occasional one such as we have here. Who lets the other two fight. While he waits. Waits until the survivor is so exhausted that he cannot defend himself. And then, like SPECTRE, he strikes.
From Russia With Love

M: What the hell is this organisation, Bond? How can they be everywhere and we know nothing about them!
Quantum Of Solace

Dr No: SPECTRE. Special Executive for Counter-intelligence, Terrorism, Revenge, Extortion. The four great cornerstones of power, headed by the greatest brains in the world.
Dr. No

Ernst Stavro Blofeld: TOTAL infertility! In plants and animals. Not just disease in a few herds, Mr Bond. Or the loss of a single crop. But the destruction of a whole strain. Forever! Throughout an entire continent. If my demands are not met, I shall proceed with the systematic extinction of whole species of cereals and livestock all over the world.
Bond: Including, I suppose, the human race?
Ernst Stavro Blofeld: I don't think, do you, Mr Bond, that the United Nations will let it come to that? Not after their scientists analyse a small sample of Virus Omega they have received.
On Her Majesty's Secret Service

Ernst Stavro Blofeld:
Well, the methods of
the great pioneers
have often puzzled
conventional minds.

*On Her Majesty's
Secret Service*

Ernst Stavro Blofeld: And SPECTRE always delivers what it promises. Our whole organisation depends on our keeping those promises. I warned you, we do not tolerate failure, Number Three. You know the penalty.

From Russia With Love

Ernst Stavro Blofeld: You will see that my piranha fish get very hungry. They can strip a man to the bone in thirty seconds. I have decided to ask for a little money in advance. I want the sum of a hundred million dollars, in gold bullion, deposited in our account in Buenos Aires.

Financier #1: Our agreement states quite clearly that no money should be paid until war has broken out between Russia and the United States.

Financier #2: This is extortion.

Ernst Stavro Blofeld: Extortion is my business. Go and think it over, gentlemen. I'm busy.

You Only Live Twice

Ernst Stavro Blofeld: The firing power inside my crater is enough to annihilate a small army. You can watch it all on TV. It's the last programme you're likely to see.

Bond: Well, if I'm going to be forced to watch television, may I smoke?

Ernst Stavro Blofeld: Yes. Give him his cigarettes. It won't be the nicotine that kills you, Mr Bond.

You Only Live Twice

Ernst Stavro Blofeld: I've really put you through it, haven't I? Well, that's brothers for you: They always know which buttons to press.

Spectre

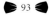

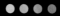

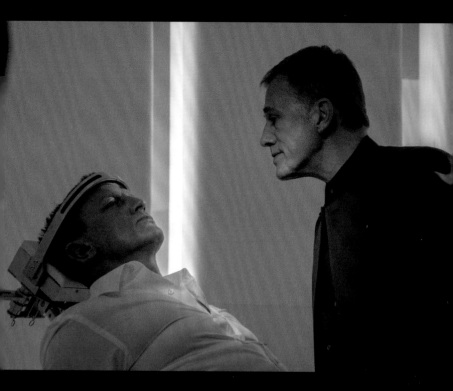

Franz Oberhauser: So, James, I'm going to penetrate to where you are. To the inside of your head. Now the first probe will play with your sight, your hearing, and your balance, just with the subtlest of manipulations.
Bond: Well, get on with it then. Nothing can be as painful as listening to you talk.

Spectre

Chapter 8

REPARTEE

Bond: Do you expect me to talk?
Goldfinger: No, Mr Bond, I expect you to die!

Goldfinger

Pussy Galore: I'm completely defenceless.
Bond: So am I.
Goldfinger

Hugo Drax: Mr Bond, you defy all my attempts to plan
an amusing death for you. You're not a sportsman, Mr Bond.
Why did you break off the encounter with my pet python?
Bond: I discovered he had a crush on me.
Moonraker

Tiffany Case: Darling, why are we suddenly staying in
the bridal suite of The Whyte House?
Bond: In order to form a more perfect union, sweetheart.
Diamonds Are Forever

Franz Oberhauser: Franz Oberhauser died
twenty years ago, James, in an avalanche alongside
his father. The man you are talking to now, the man
inside your head, is Ernst Stavro Blofeld.
Spectre

Dr No: I was curious to see what kind of a man you were.
I thought there may even be a place for you with SPECTRE.
Bond: And I'm flattered. I'd prefer the revenge department.
Dr. No

Bond: Tell me, do you always dress this way for golf?
Sylvia Trench: I changed into something more comfortable.
Oh, I hope I did the right thing?
Dr. No

Miss Caruso: Mm, such a delicate touch.
Bond: Sheer magnetism, darling.
Live And Let Die

General Georgi Koskov: I'm sorry, James. For you I have great
affection, but we have an old saying: Duty has no sweethearts.
Bond: We have an old saying too, Georgi, and you're full of it.
The Living Daylights

Bond: My department know I'm here. When I don't report they'll retaliate.
Max Zorin: If you're the best they have, they'll more likely try to
cover up your embarrassing incompetence.
Bond: Don't count on it, Zorin.
Max Zorin: Haha, you amuse me, Mr Bond.
Bond: Well, it's not mutual.
A View To A Kill

Kamal Khan: You have a nasty habit of surviving.
Bond: Well, you know what they say about the fittest.
Octopussy

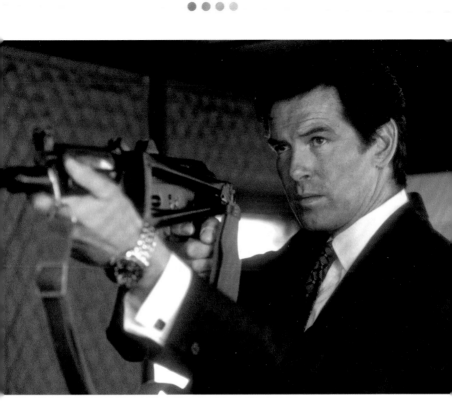

Alec Trevelyan: Why can't you just
be a good boy and die?
Bond: You first.

GoldenEye

 99

Dr No: The glass is convex, ten inches thick, which accounts for the magnifying effect.
Bond: Minnows pretending they're whales. Just like you on this island, Dr No.
Dr No: It depends, Mr Bond, on which side the glass you are.

Dr. No

Franz Oberhauser: So, James, why did you come?
Bond: I came here to kill you.
Franz Oberhauser: And I thought you came here to die.
Bond: Well, it's all a matter of perspective.
Spectre

Bond: Then you'll also know that in poker you
never play your hand.
You play the man across from you.
Vesper Lynd: And you're good at reading people?
Bond: Yes, I am. Which is why I've been able to detect
an undercurrent of sarcasm in your voice.
Casino Royale

Bond: You were pretty good with that hook.
Wai Lin: It comes from growing up in a rough neighbourhood.
Bond: Uh-huh.
Wai Lin: You were pretty good on the bike.
Bond: Well, that comes from not growing up at all.
Tomorrow Never Dies

Bond: You know, you're cleverer than you look.
Q: Hmm. Still, better than looking
cleverer than you are.
Die Another Day

Bond: Where did you learn to fight like that? NASA?
Holly Goodhead: No. Vassar.

Moonraker

Bond: Hello, Penny.
Moneypenny: You'd better go right in.
You're late, as usual – even from your own funeral.
Bond: Well, we corpses have absolutely
no sense of timing.

You Only Live Twice

Chapter 9

A FOND FAREWELL

Dryden: Your file shows no kills
and it takes—
Bond: Two.

Casino Royale

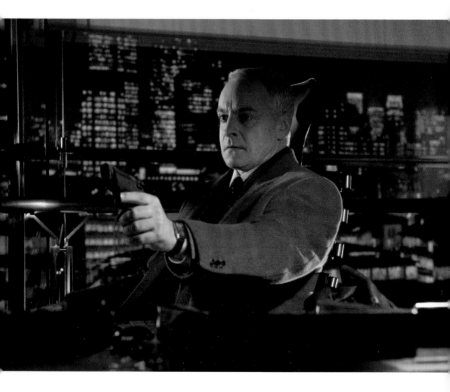

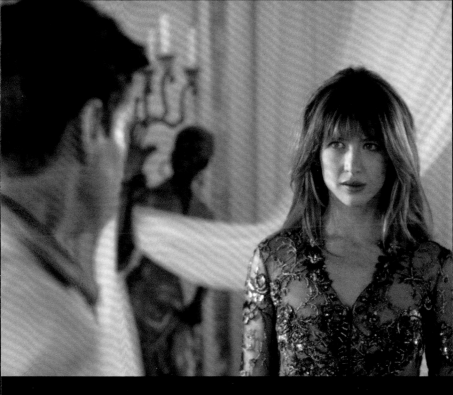

Elektra King: You wouldn't kill me. You'd miss me.
Renard [over radio]: Yes?
Elektra King: Dive! Bond—
Bond: I never miss.

The World Is Not Enough

Policeman #1: We're too late.
Policeman #2: Well, at least he died on the job.
Policeman #1: He'd have wanted it this way.
You Only Live Twice

Bond: Baines. I rather liked Baines.
We shared the same bootmaker.
Live And Let Die

Bond: Shocking... Positively shocking.
Goldfinger

Domino: Vargas is behind you.
Bond: Really?
Domino: He must've followed us.
Bond: I think he got the point.
Thunderball

Bond: You forgot the first rule of mass media, Elliot:
Give the people what they want!
Tomorrow Never Dies

Bond: All those feathers and he still can't fly.
The Spy Who Loved Me

Tiffany Case: Is he dead?
Bond: I sincerely hope so.

Diamonds Are Forever

Bond: There's a saying in England: Where's there's smoke, there's fire.

From Russia With Love

Pussy Galore: What happened? Where's Goldfinger?
Bond: Playing his golden harp.

Goldfinger

Professor Dent: Very clever, Mr Bond.
But you're up against more than you know.
You shoot me and you'll end up like Strangways.
Bond: Then you killed him?
Professor Dent: He was killed, but never mind how.
Bond: Who are you working for, professor?
Professor Dent: You might as well know as you won't
live to use the information. I'm working for...
Bond: That's a Smith & Wesson and
you've had your six.

Dr. No

Tatiana Romanova: Horrible woman.
Bond: Yes. She's had her kicks.

From Russia With Love

Holly Goodhead: Where's Drax?
Bond: Oh, he had to fly.
Moonraker

Bond: He had lots of guts.
On Her Majesty's Secret Service

Alec Trevelyan: For England, James?
Bond: No. For me.
GoldenEye

Bond: Oh, he blew a fuse.
Goldfinger

Construction Worker: How did it happen?
Bond: I think they were on their way to a funeral.
Dr. No

Bond: Well, he always did have
an inflated opinion of himself.
Live And Let Die

Bond: Mind if my friend sits this one out?
She's just dead.

Thunderball

Chapter 10

THE END

Tatiana Romanova: Here you are, in
case you ever need it again.
Bond: Oh, yes. All government property has to be
accounted for. But, as I said before, we won't always be
working on the company's time, will we?
Tatiana Romanova: No... James, behave yourself.
From Russia With Love

Bond: Oh no, you don't.
This is no time to be rescued.
Goldfinger

Bond: Well, he certainly left with his tails between his legs.
Tiffany Case: Oh, James.
Bond: Oh, yes, what were you about to ask me?
Tiffany Case: James, how the hell do we
get those diamonds down again?
Diamonds Are Forever

Wai Lin: They're looking for us, James.
Bond: Let's stay undercover.
Tomorrow Never Dies

Bond: The name's Bond. James Bond.
Casino Royale

Felix Leiter: Ahoy, Mr Bond. Ahoy, Mr Bond.
Bond: Well, well, what's the matter? Do you need help?
Felix Leiter: Quite sure you don't.
Bond: Well, now that you're here, you'd better give us a tow.
Felix Leiter: Throw us your line.

Dr. No

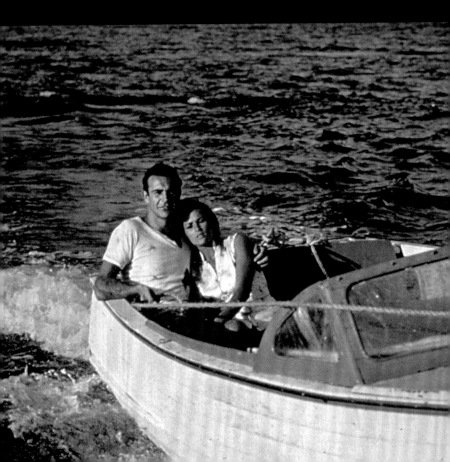

M: You'll be glad to know I straightened things out with the Americans. Your friend Leiter's been promoted. He replaced Beam.

Bond: Well, then the right people kept their jobs.

M: Something like that.

Bond: Congratulations, you were right.

M: About what?

Bond: About Vesper... Ma'am.

M: Bond, I need you back.

Bond: I never left.

Quantum Of Solace

Bond: It's all right. It's quite all right, really. She's having a rest. We'll be going on soon. There's no hurry, you see. We have all the time in the world.

On Her Majesty's Secret Service

Kara Milovy: [Whistles]
Bond: [Whistles] You didn't think I'd miss this performance, did you?
Kara Milovy: Oh, James.

The Living Daylights

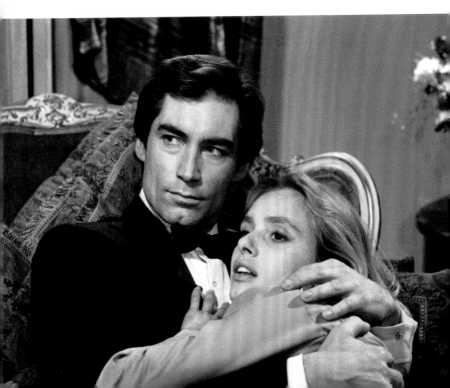

Q: Bond. Bond!

Parrot: Bond. Bond.

Q: He's there.

Minister of Defence: Patch in the Prime Minister.

Phone rings

Prime Minister: I'll get it Denis. Hello.

Tanner: Mr Bond on the line, Prime Minister.

Prime Minister: Ah. Mr Bond. I wanted to call you personally and to say how pleased we all are that your mission was a success. Thank you.

Parrot: Thank you. Thank you.

Prime Minister: Don't thank me, Mr Bond. Your courage and resourcefulness are a credit to the nation. Denis and I look forward to meeting you. Meanwhile, if there is anything I can do for you...

Parrot: Give us a kiss. Give us a kiss.

Prime Minister: Well, really, Mr Bond. A-hahaha.

Tanner: I think we're having a little trouble with the line, madam.

Parrot: Give us a kiss.

Minister of Defence [to Q]: You idiot. Get on to him.

Q: 007. 007!

Parrot: [Laughing]

Minister of Defence: Bond. Have you gone mad? What's going on? Bond. Bond. Bond!

For Your Eyes Only

Solitaire: Well, that wasn't very funny.
Now what are you doing?
Bond: Just being disarming, darling.
Live And Let Die

Holly Goodhead: James?
Bond: I think it may be time to go home.
Holly Goodhead: Take me round
the world one more time?
Bond: Why not.
Moonraker

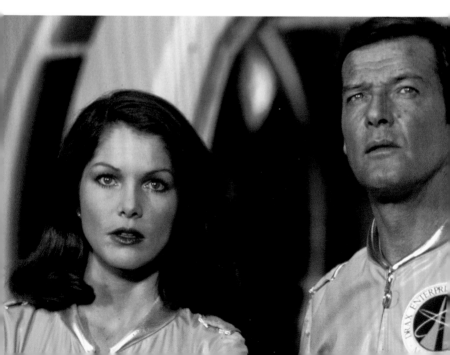

Pam Bouvier: Why don't you
wait until you're asked.
Bond: So why don't you ask me?

Gareth Mallory: So, 007... Lots to be done.
Are you ready to get back to work?
Bond: With pleasure, M. With pleasure.

Skyfall

Ernst Stavro Blofeld: Finish it... Finish it.
Bond: Out of bullets. And besides,
I've got something better to do.
M [to Ernst Stavro Blofeld]: Under the
Special Measures Act of 2001 I am detaining
you on behalf of Her Majesty's Government.

Spectre